VIEWS

SEATTLE AND THE PUGET SOUND

EMERALD POINT PRESS

an imprint of

ISBN 10: 0-9637816-1-8
ISBN 13: 978-0-9637816-1-1

Copyright © 2006
Thunder Bay Press, Holt, Michigan

Copyright © 2002
Emerald Point Press, Seattle, Washington
An imprint of Thunder Bay Press

Library of Congress Catalog Card Number 95-60449

Printed in China

It is the artists interpretation of reality, that help us view life, in perspectives that we otherwise may not see. These views of Seattle and the Puget Sound, were all produced by Seattle area photographers. These seasonal images, capture forever, that moment in time, when all forces necessary to create perfection converge.

The city and landscape photographs reproduced in this book, were created by: Bill Brooksher, Dan Carow, John S. Chao, Adrienne DeLiso, Joe Faulkner, Neal Herbert, Chris Jacobson, S.H. Marti, Joe Poehlman, and John Rizzo.

Their artistic vision is yours to enjoy.

▲

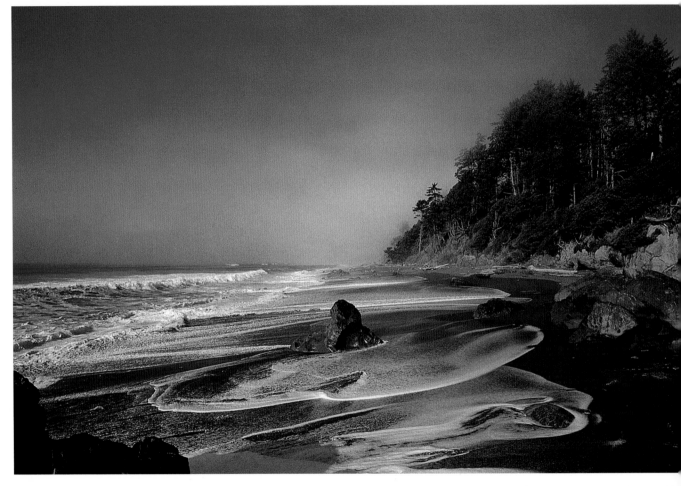

South of Ruby Beach—Olympic National Park Seashore

Adrienne DeLiso

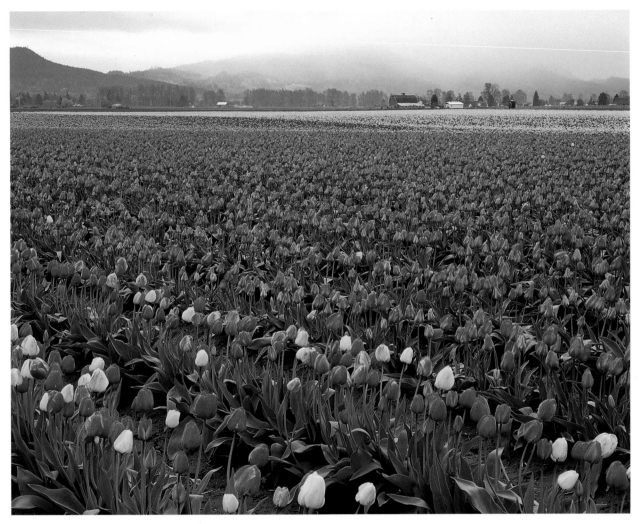

John S. Chao

TULIP FIELDS—SKAGIT VALLEY

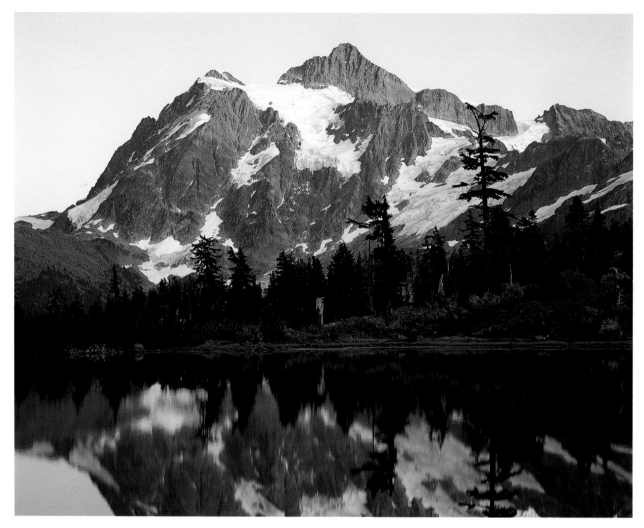

Mount Shuksan viewed from Picture Lake—Mount Baker Wilderness

Chris Jacobson

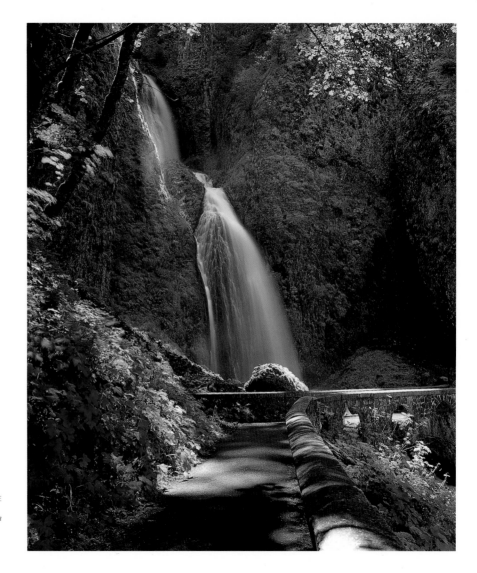

WAHKEENA FALLS—COLUMBIA RIVER GORGE

Chris Jacobson

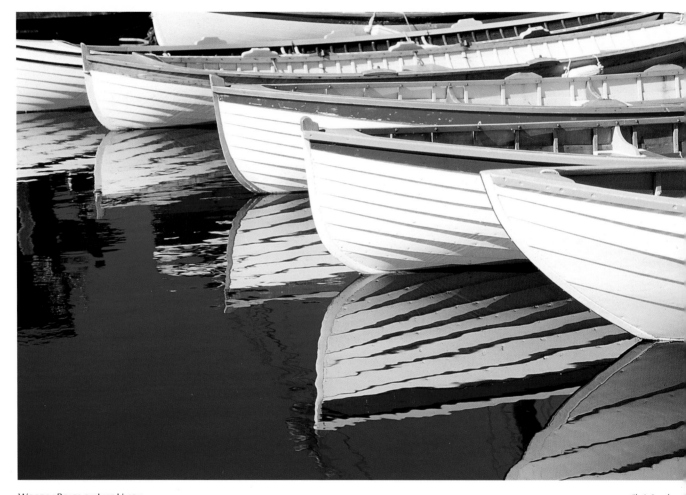

Wooden Boats on Lake Union

Chris Jacobson

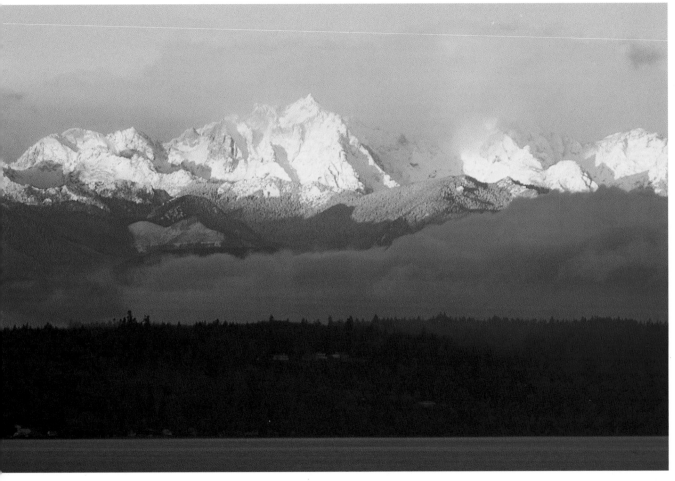

Joe Poehlman

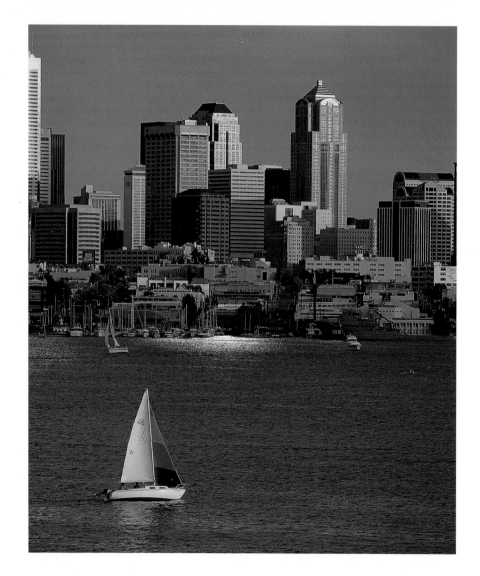

SEATTLE VIEWED FROM LAKE UNION

Chris Jacobson

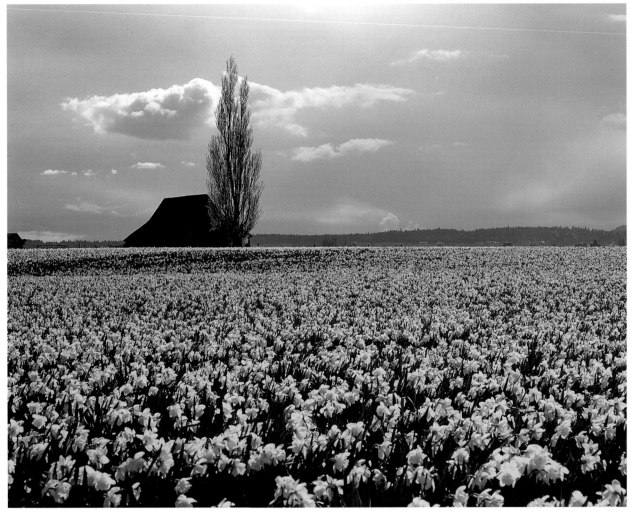

Chris Jacobson

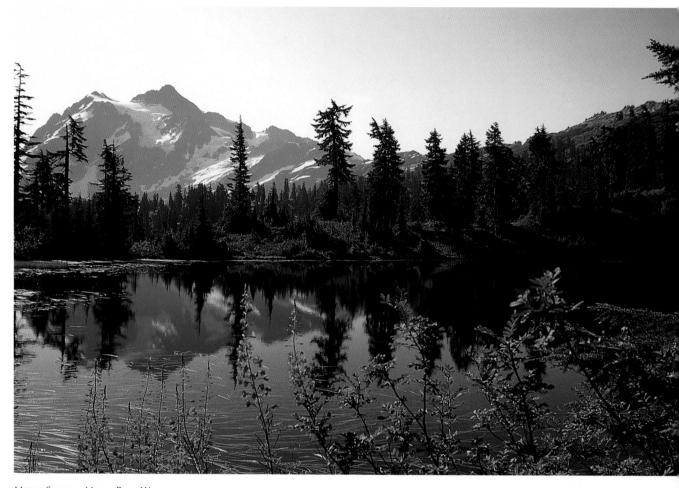

Mount Shuksan–Mount Baker Wilderness

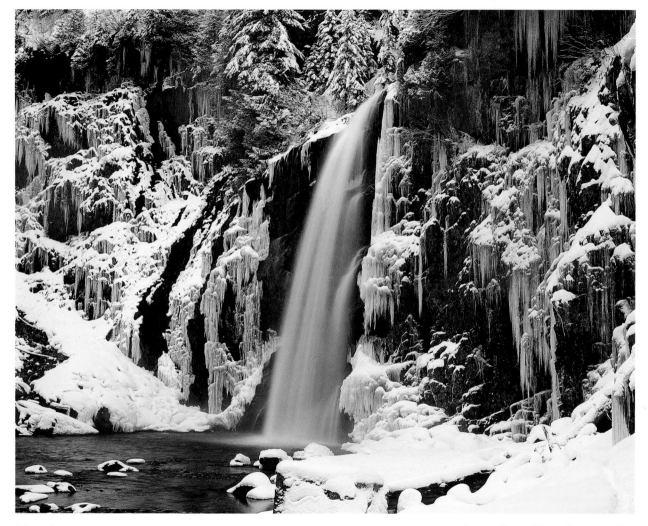

John S. Chao

FRANKLIN FALLS IN WINTER—SNOQUALMIE PASS

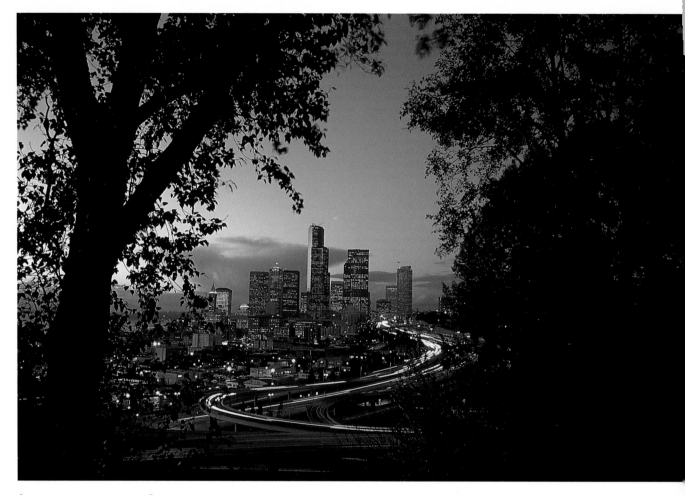

SEATTLE AT DUSK VIEWED FROM THE SOUTH

Joe Poehlman

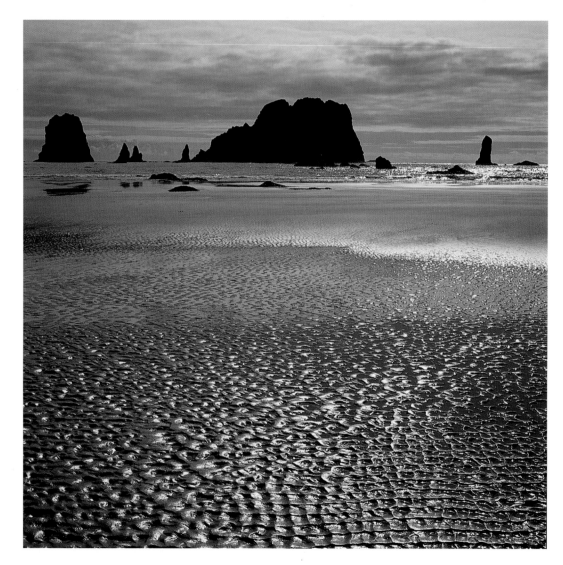

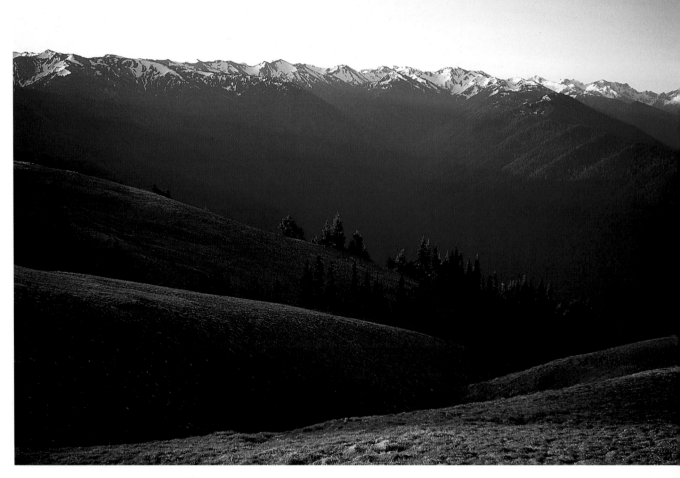

VIEW FROM HURRICANE RIDGE—OLYMPIC NATIONAL PARK

Dan Carou

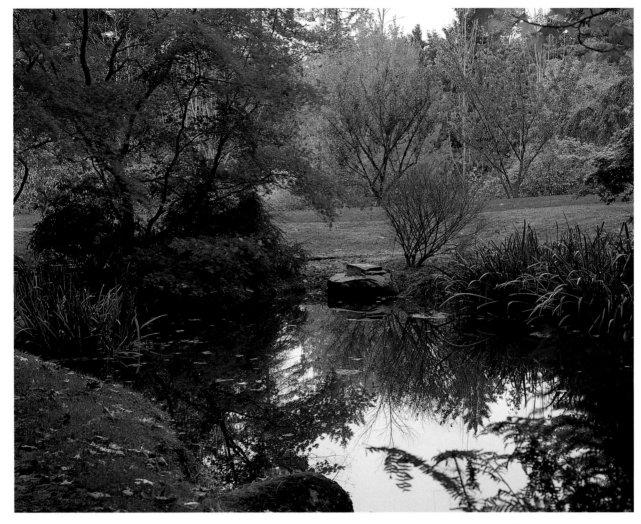

Chris Jacobson

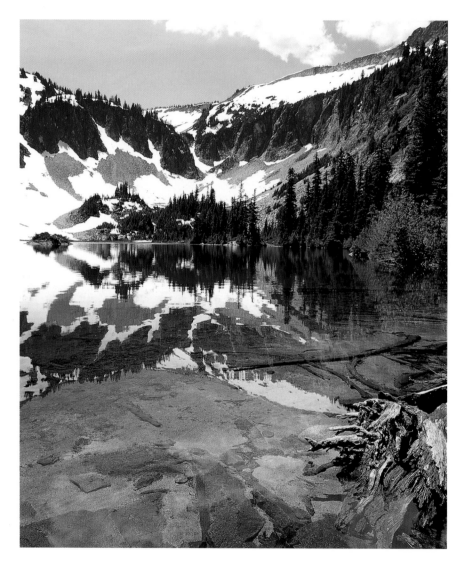

SNOW LAKE—MOUNT RAINIER NATIONAL PARK

Chris Jacobson

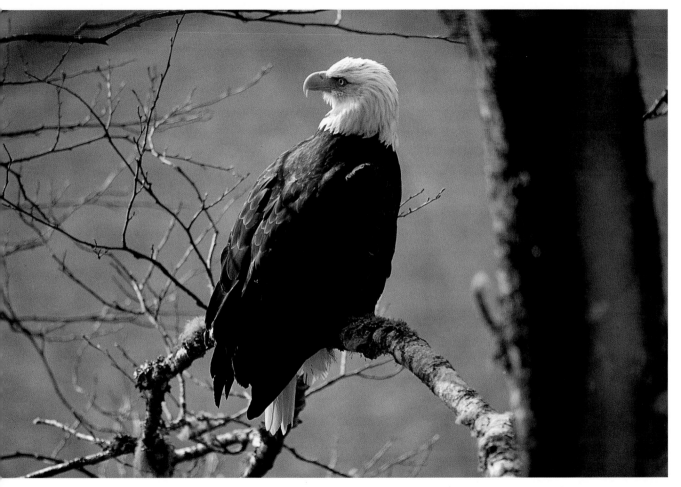

Adrienne DeLiso

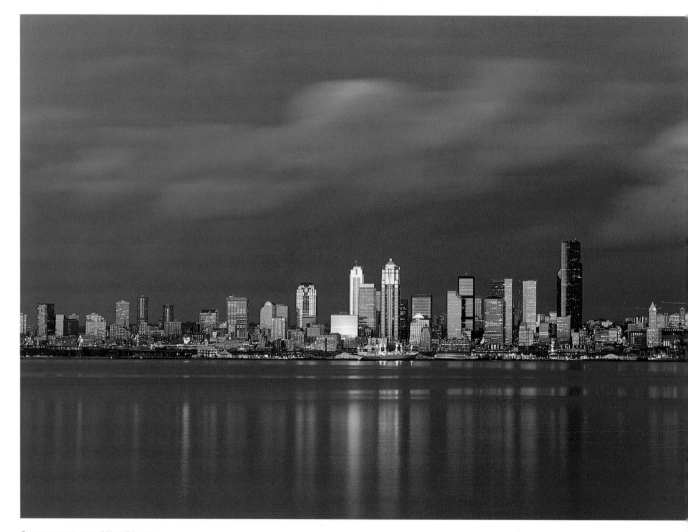

SEATTLE VIEWED FROM WEST SEATTLE

Bill Brooksher

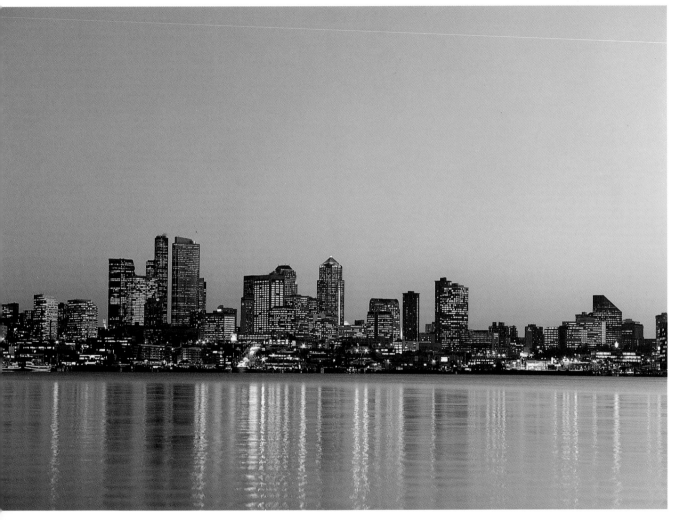

Bill Brooksher

SEATTLE VIEWED FROM LAKE UNION

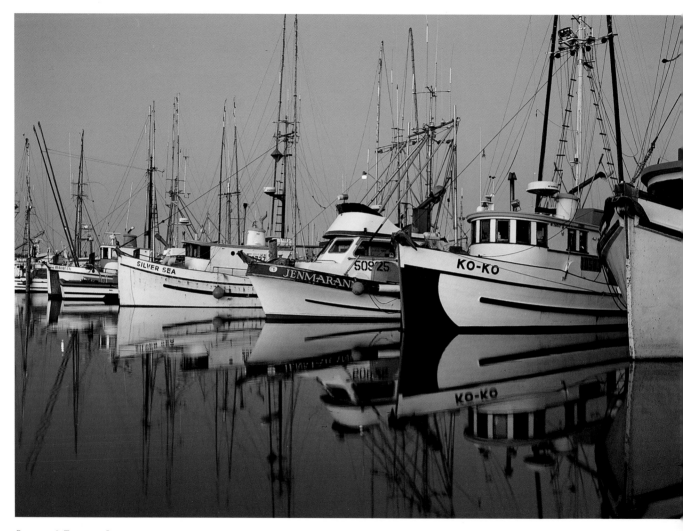

FISHERMAN'S TERMINAL—SEATTLE

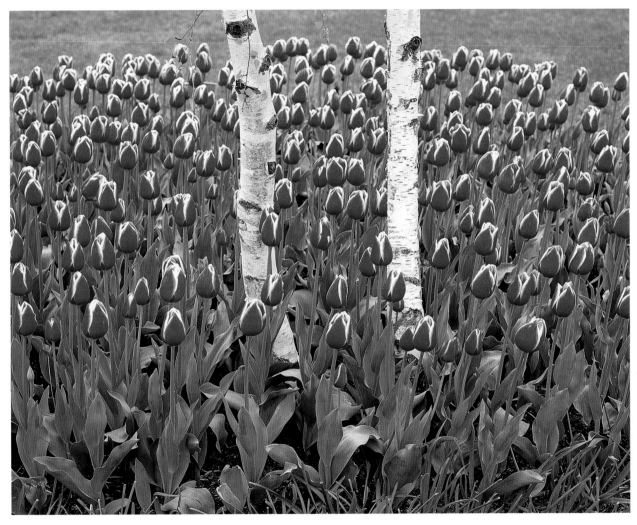

Chris Jacobson

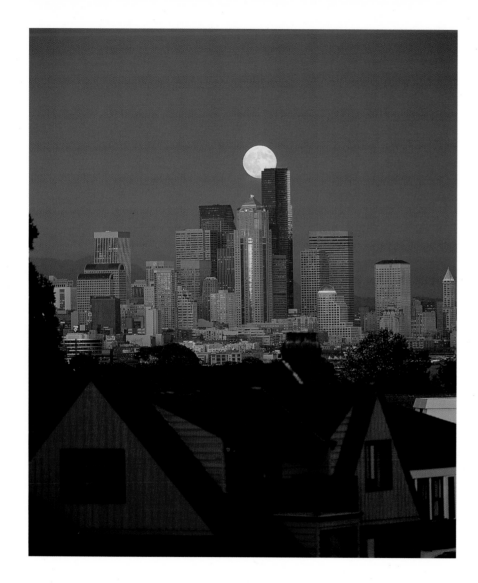

MOONRISE IN SEATTLE FROM MAGNOLIA PARK

Chris Jacobson

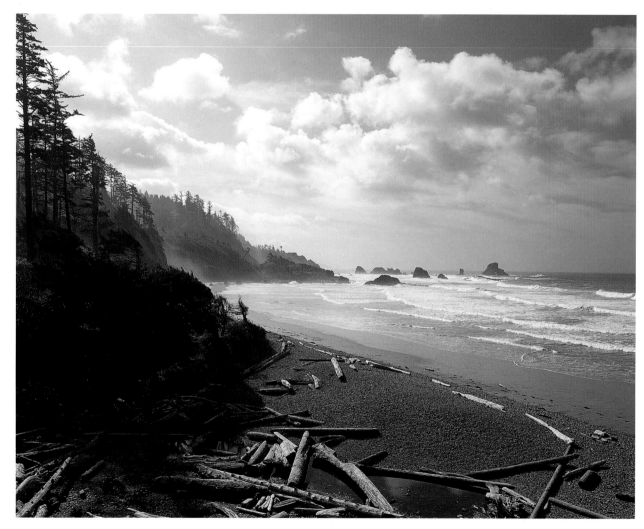

Chris Jacobson

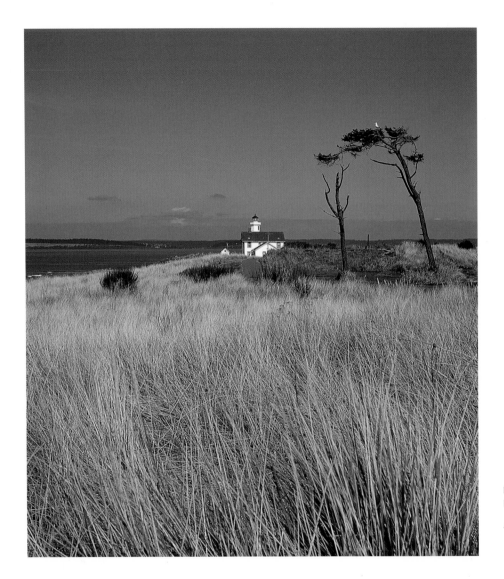

POINT WILSON LIGHTHOUSE
FORT WORDEN STATE PARK

Adrienne DeLiso

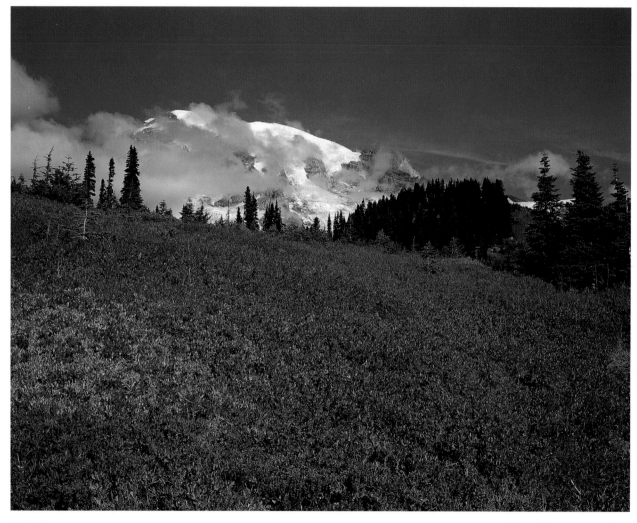

Joe Faulkner

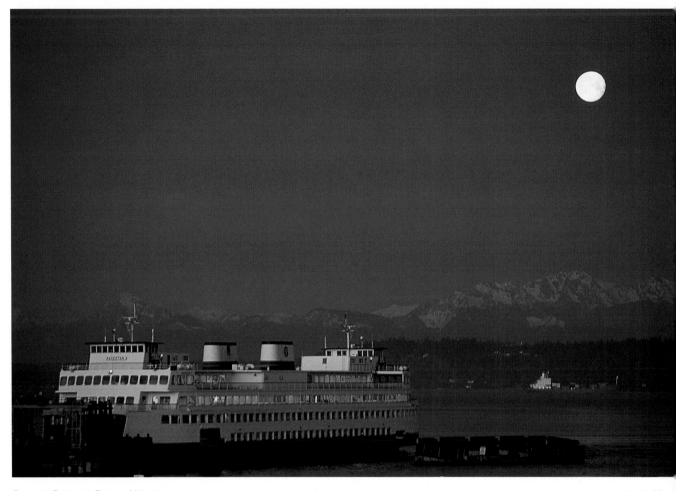

EDMONDS FERRY AND OLYMPIC MOUNTAINS

Joe Poehlma

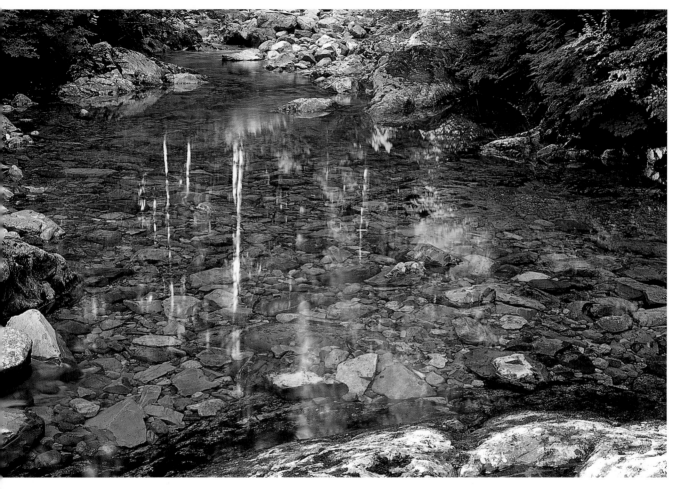

John S. Chao

SOURCE LAKE STREAM—SNOQUALMIE PASS

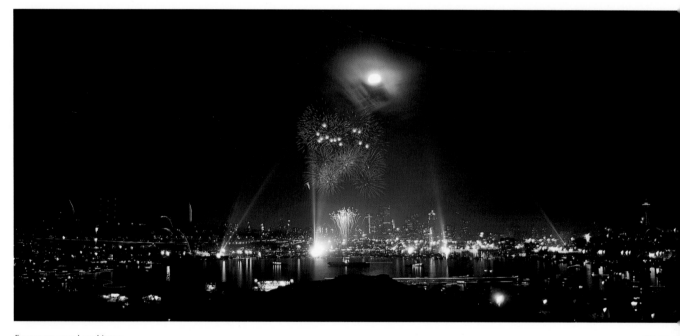

FIREWORKS OVER LAKE UNION

S.H. Mart

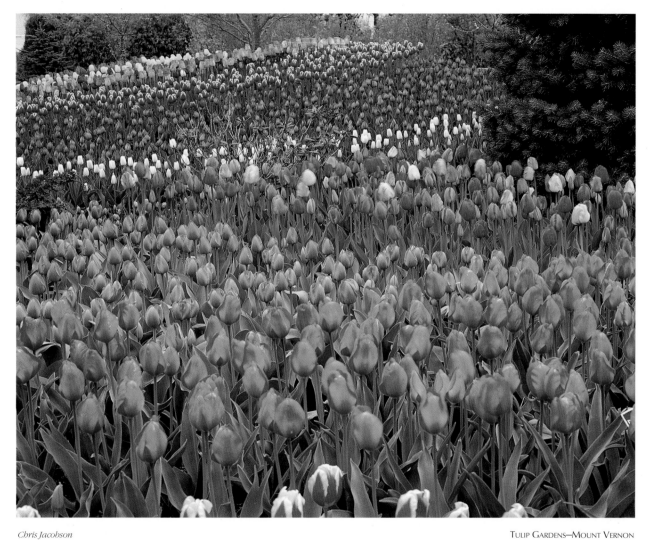

Chris Jacobson

TULIP GARDENS—MOUNT VERNON

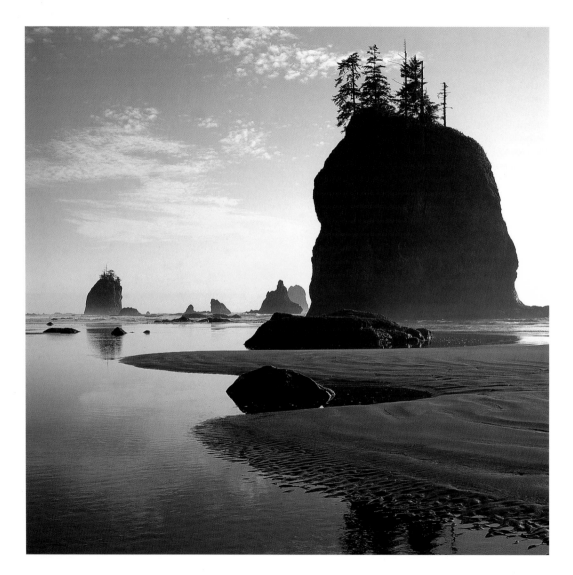

SEA STACKS
OLYMPIC NATIONAL PARK
SEASHORE

Neal Herbert

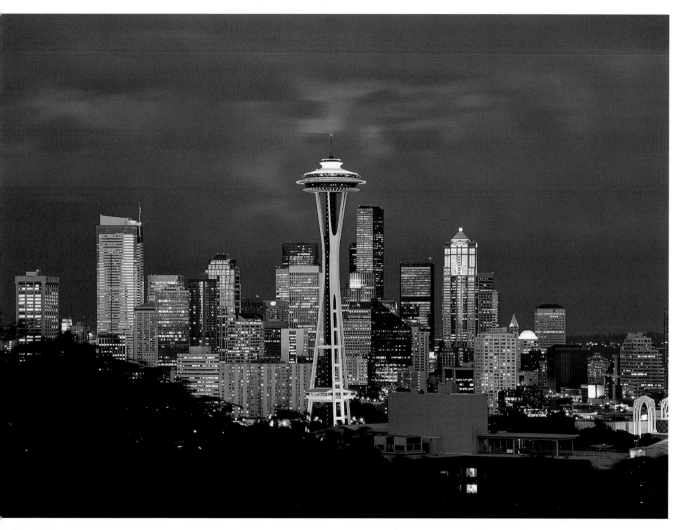

Bill Brooksher

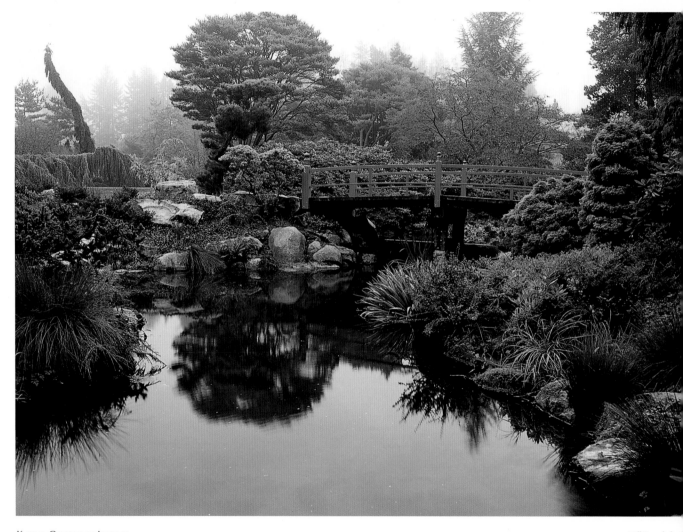

KUBOTA GARDENS IN AUTUMN

Bill Brooksher

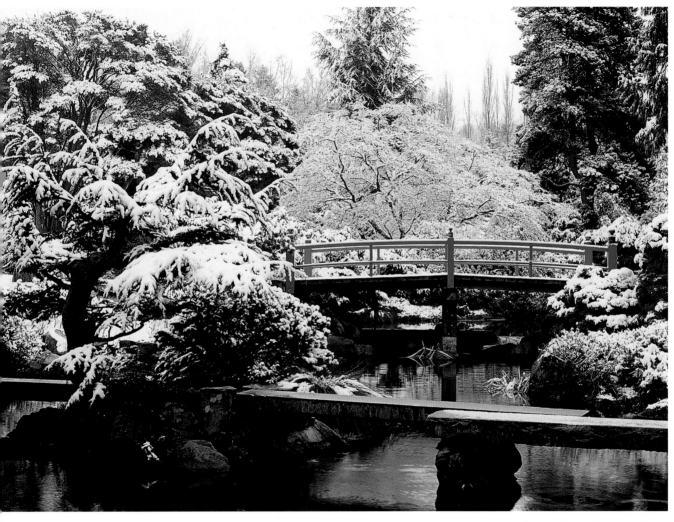

Bill Brooksher

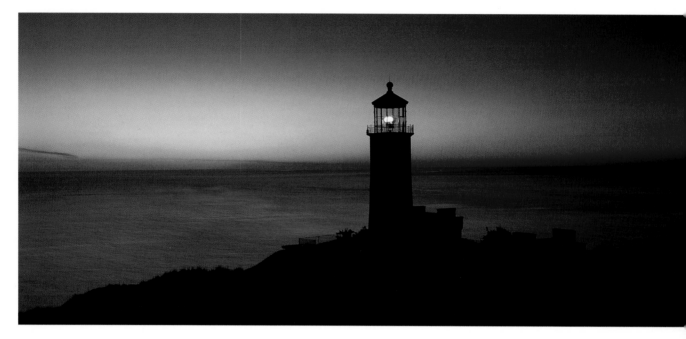

NORTH HEAD LIGHTHOUSE—COLUMBIA RIVER

S.H. Mart

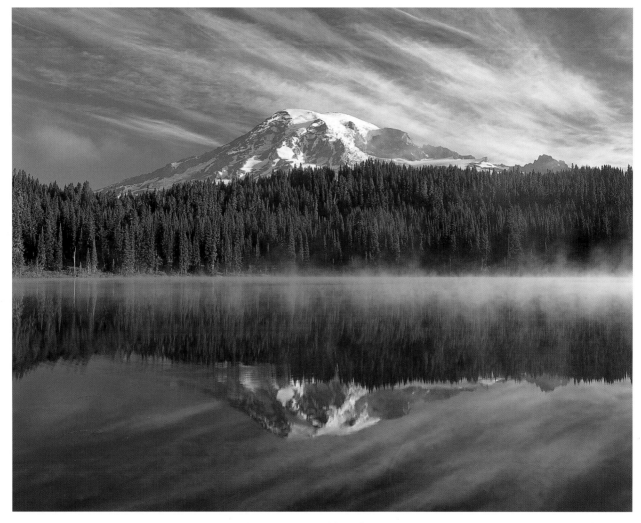

Chris Jacobson

MOUNT RAINIER VIEWED FROM REFLECTION LAKES—MOUNT RAINIER NATIONAL PARK

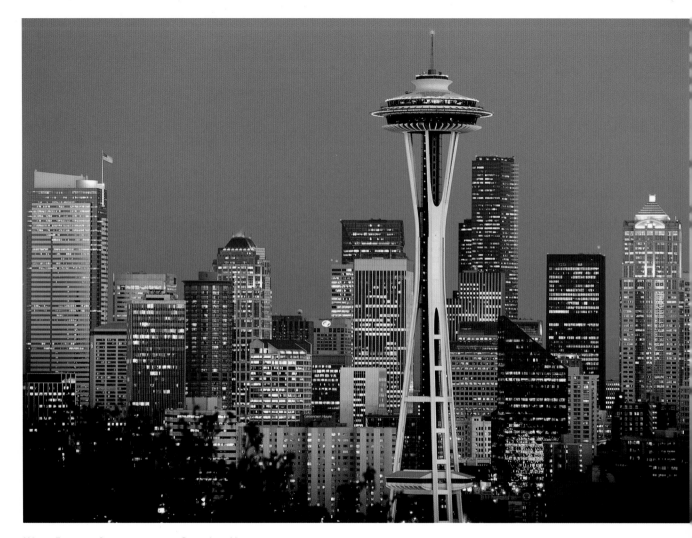

WINTER EVENING IN SEATTLE VIEWED FROM QUEEN ANNE HILL

Bill Brooksher

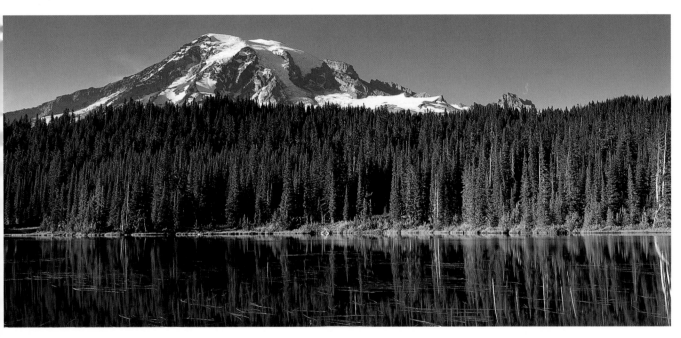

MOUNT RAINIER VIEWED FROM REFLECTION LAKES–MOUNT RAINIER NATIONAL PARK

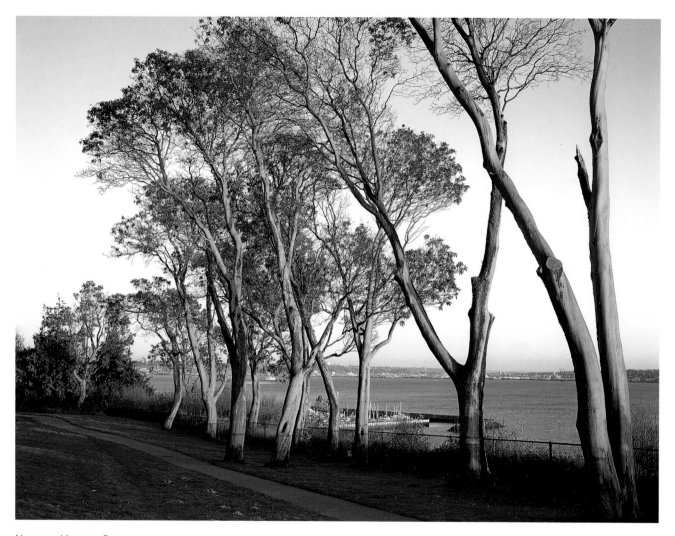

VIEW FROM MAGNOLIA PARK

Joe Faulkner

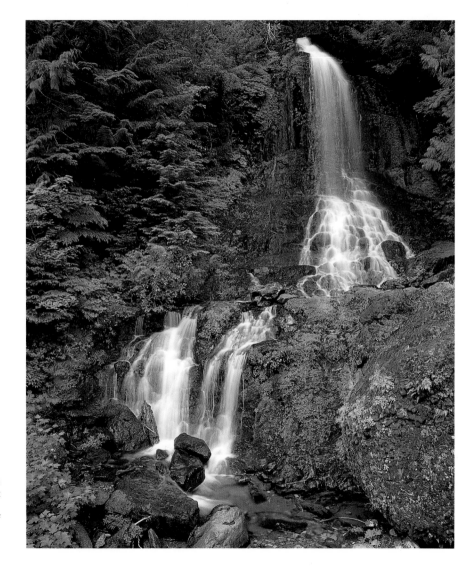

FALLS CREEK FALLS NEAR OHANAPECOSH
MOUNT RAINIER NATIONAL PARK

Chris Jacobson

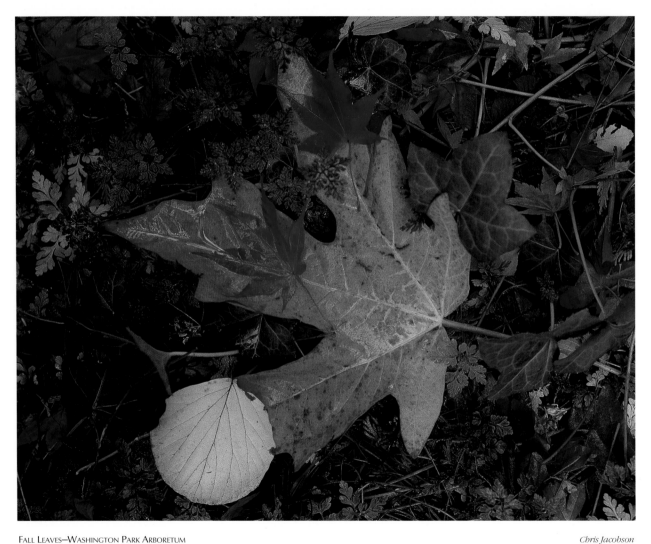

FALL LEAVES—WASHINGTON PARK ARBORETUM

Chris Jacobson

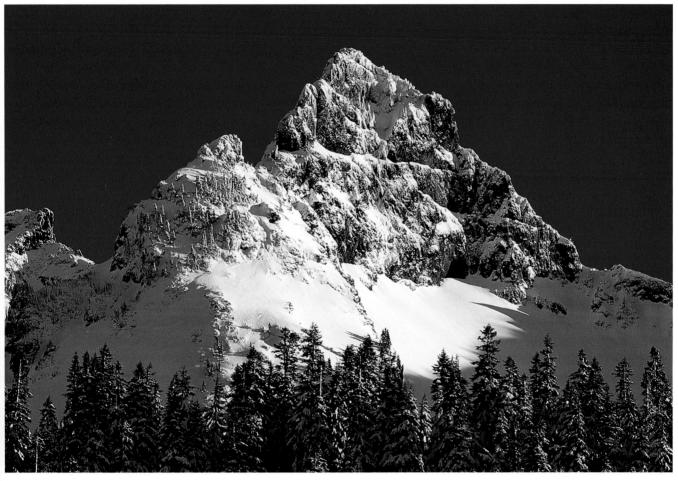

PINNACLE PEAK–MOUNT RAINIER NATIONAL PARK

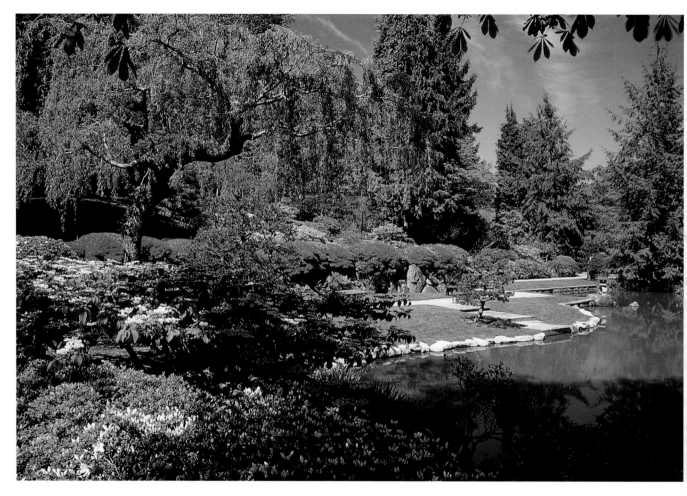

JAPANESE GARDEN—WASHINGTON PARK ARBORETUM

Joe Poehlman

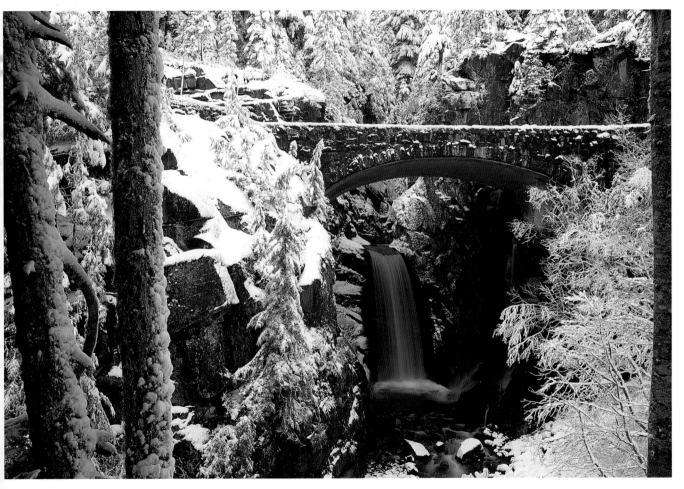

Chris Jacobson

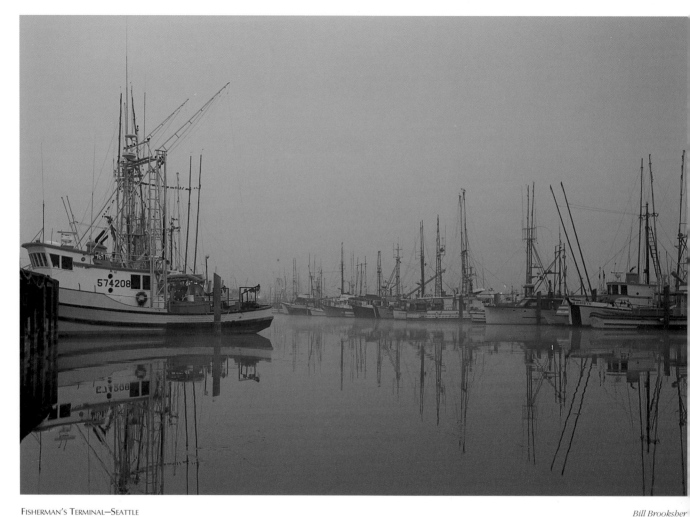

FISHERMAN'S TERMINAL—SEATTLE

Bill Brooksher

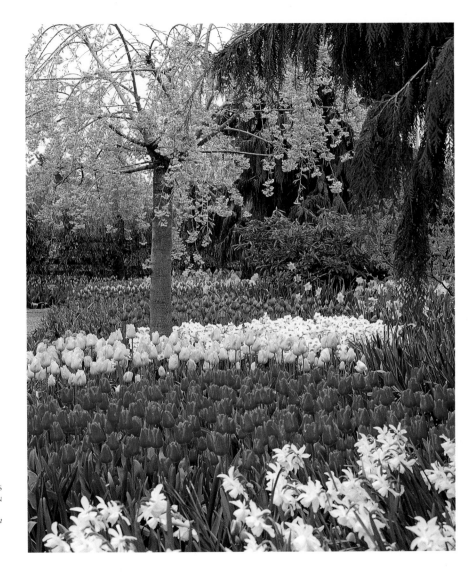

TULIP GARDENS
MOUNT VERNON

Chris Jacobson

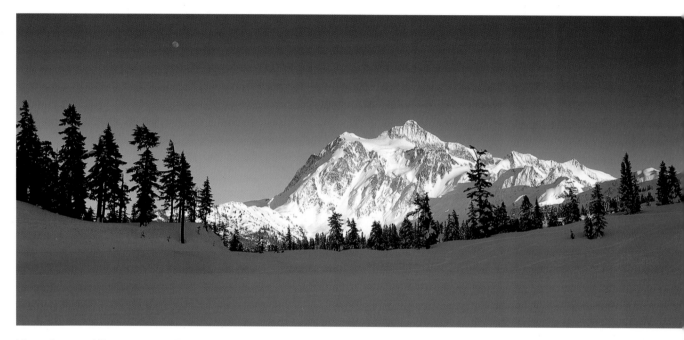

MOUNT SHUKSAN IN WINTER VIEWED FROM PICTURE LAKE—MOUNT BAKER WILDERNESS

S.H. Marti

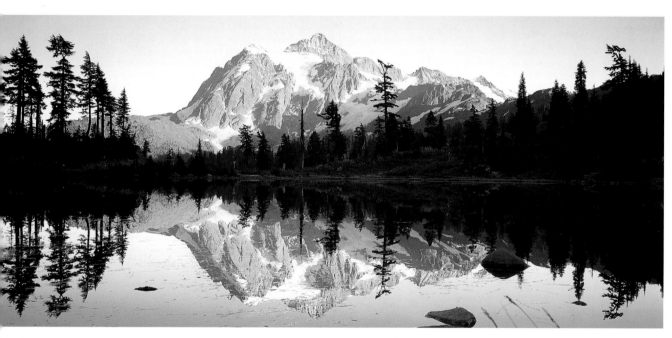

H. Marti

MOUNT SHUKSAN IN FALL VIEWED FROM PICTURE LAKE—MOUNT BAKER WILDERNESS

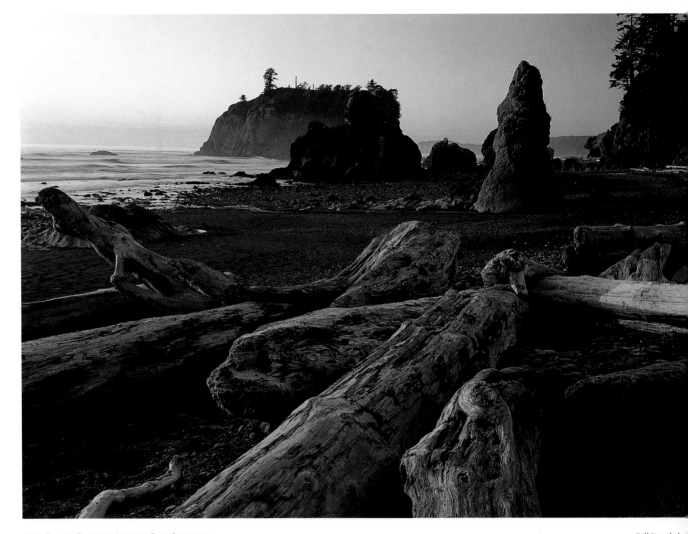

RUBY BEACH—OLYMPIC NATIONAL PARK SEASHORE

Bill Brookshe

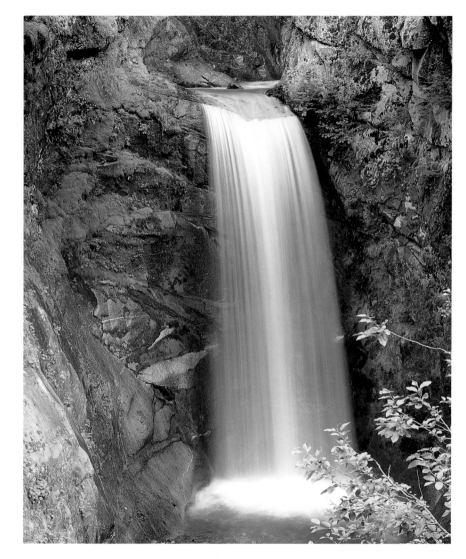

CRYSTAL FALLS
MOUNT RAINIER NATIONAL PARK

Chris Jacobson

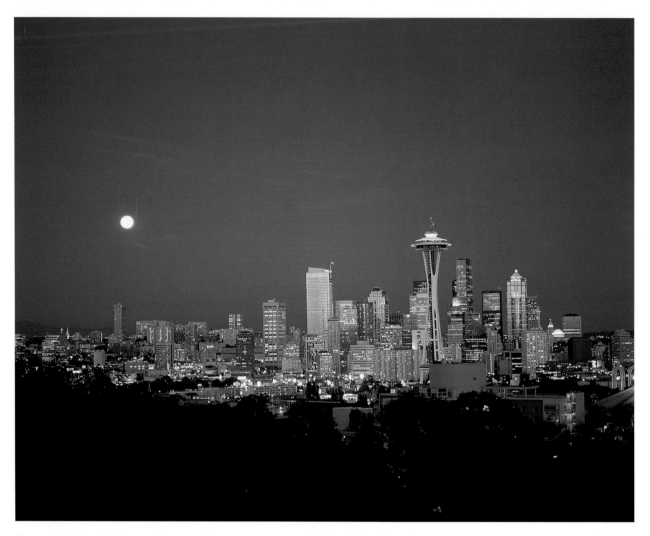

Seattle viewed from Kerry Park on Queen Anne Hill

Chris Jacobson

5

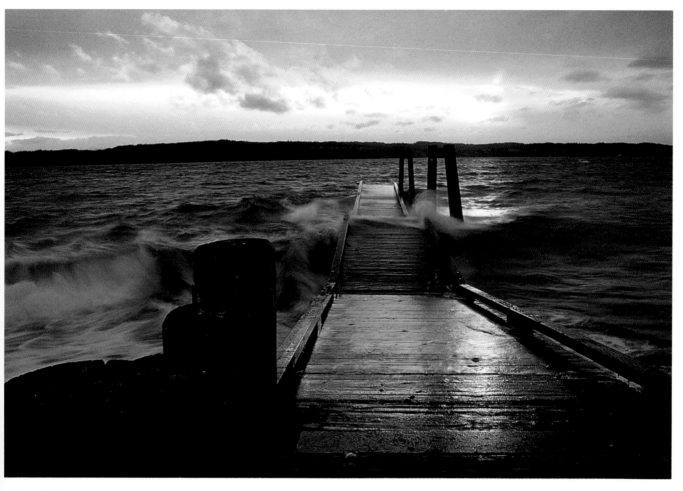

Adrienne DeLiso

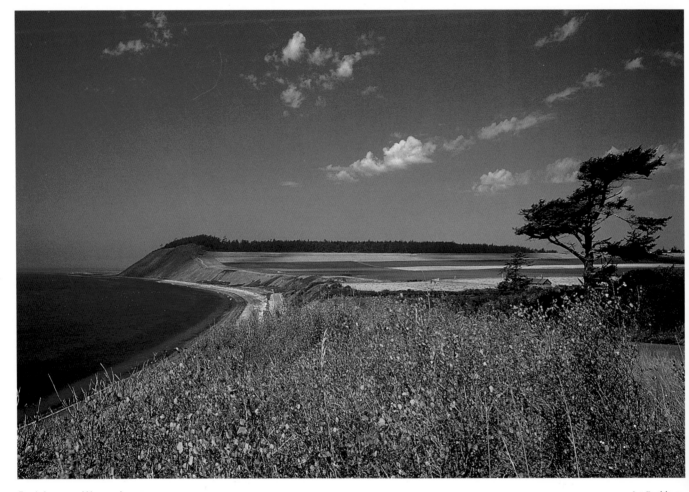

EBEY'S LANDING—WHIDBEY ISLAND

Joe Poehlman

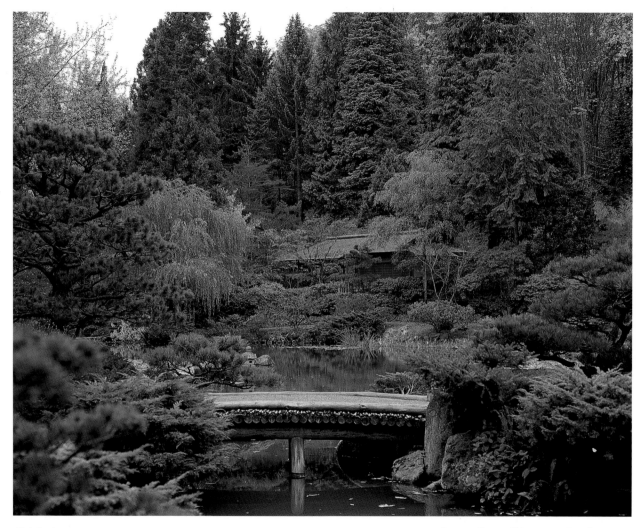

Chris Jacobson

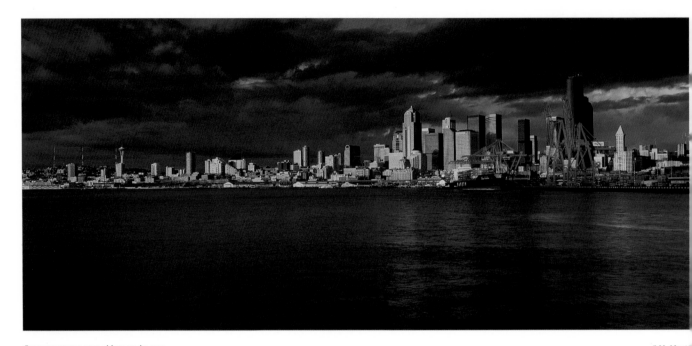

SEATTLE VIEWED FROM HARBOR ISLAND

S.H. Mart

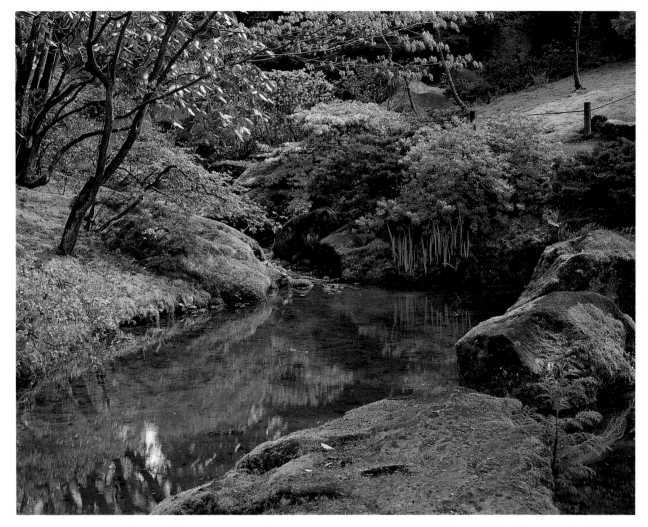

Chris Jacobson

JAPANESE GARDEN—WASHINGTON PARK ARBORETUM

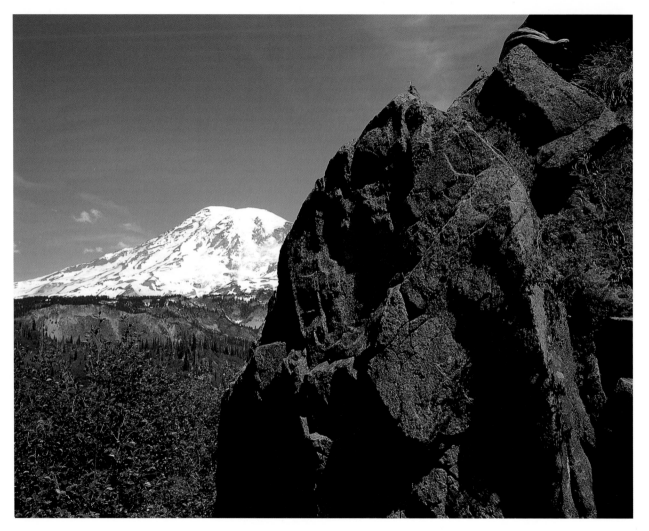

Mount Rainier viewed from the Snow Lake Trail—Mount Rainier National Park

Chris Jacobson

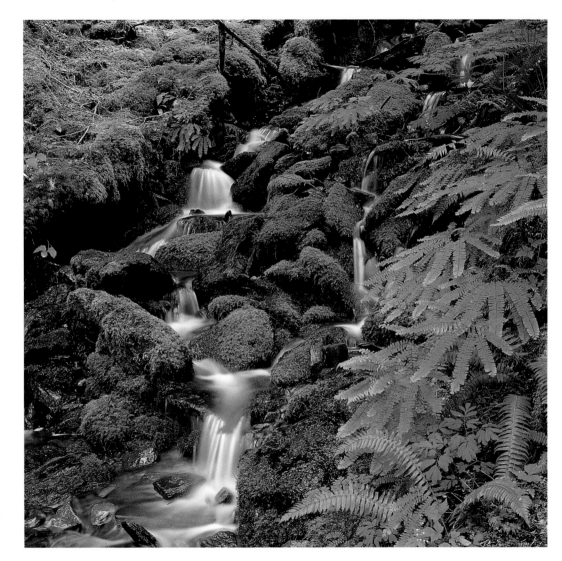

HOH RAIN FOREST
OLYMPIC NATIONAL PARK

Neal Herbert

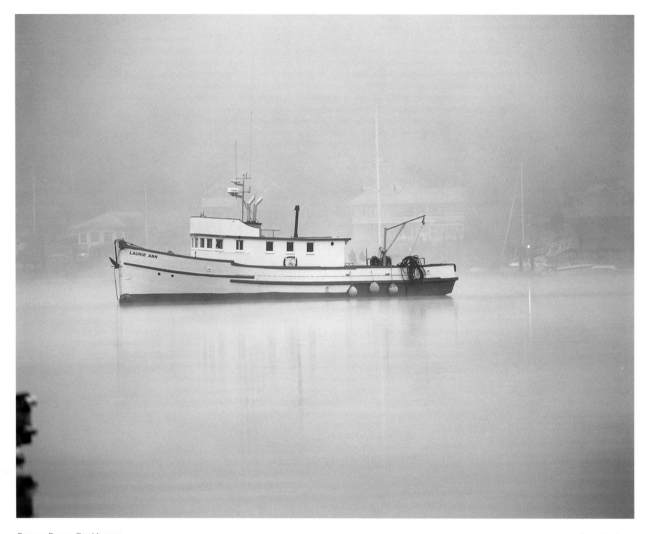

Fishing Boat—Gig Harbor

Chris Jacobson

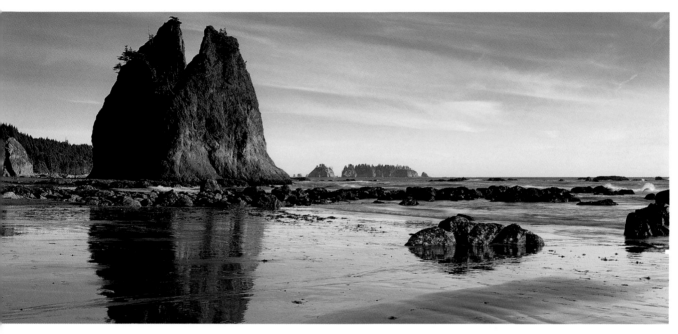

S.H. Marti

Sea Stacks—North Rialto Beach—Olympic National Park Seashore

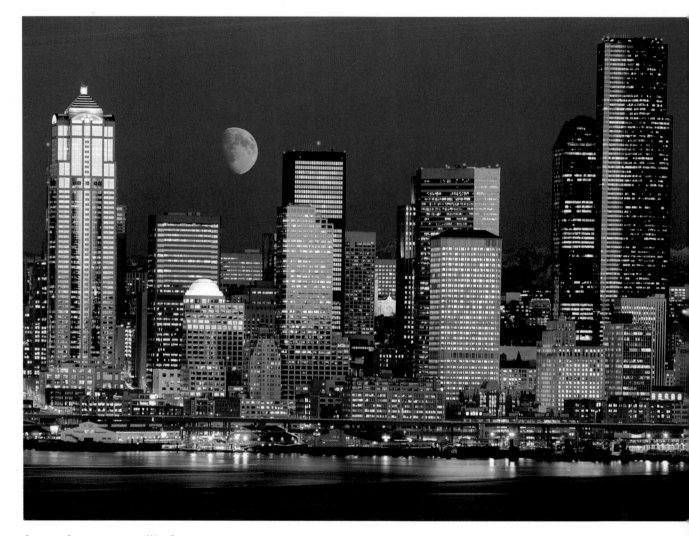

SEATTLE AT SUNSET VIEWED FROM WEST SEATTLE

Bill Brookshe

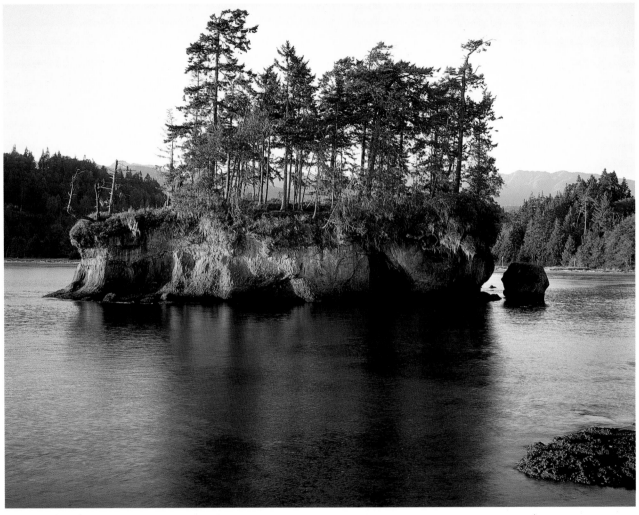

John Rizzo